How to Draw

Exotic Flowers

In Simple Steps

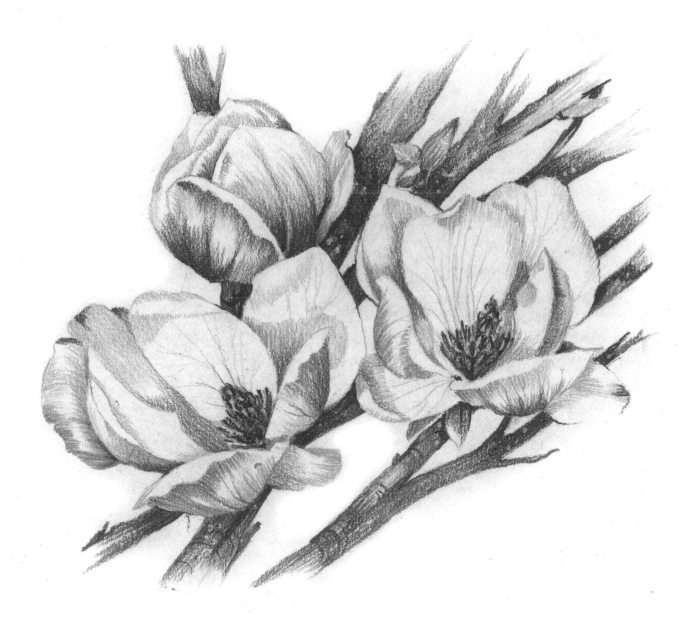

First published in Great Britain 2011

Search Press Limited
Wellwood, North Farm Road,
Tunbridge Wells, Kent TN2 3DR

Reprinted 2012, 2013, 2015

Text copyright © Janet Whittle 2011

Design and illustrations copyright © Search Press Ltd. 2011

ISBN: 978-1-84448-636-6

Printed in Malaysia

Dedication

For Matthew with love always

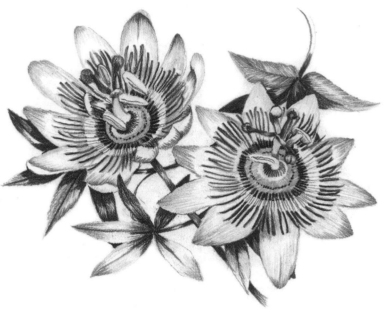

Illustrations

How to Draw
Exotic Flowers
In Simple Steps

Janet Whittle

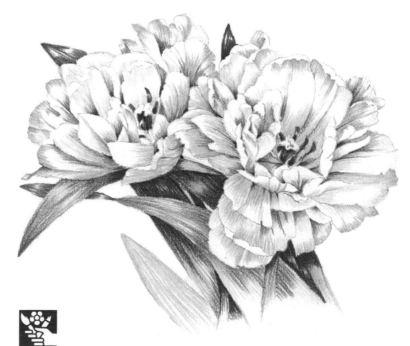

Search Press

Introduction

Flowers, with their great variety of colour and form, are one of the most fascinating subjects for drawing, especially if they originate from distant lands. I have chosen the twenty-eight flowers in this book as much for their claim to be exotic as for their 'wow' factor. Their form and vibrant colours will stand out in any garden and they are a must-have for any enthusiast. There is a good mix of simple flowers and others which are slightly more intricate; these will be more of a challenge, but as your understanding of the shape and form progresses with practice, you will find that the end results will be more impressive. The variety of different flower sizes, shapes and colours will be invaluable to use for reference when you branch out and try your own ideas.

Each drawing takes you through a sequence of basic steps, which are followed by a tonal drawing, then a finished painting. The aim is to encourage you to draw by reducing images down to simple shapes; as a result the whole drawing process becomes easier. The compositions are simple to start with and some are a little more complex, but the step-by-step illustrations build up the images and should see you safely through your first attempts to draw them and then to try the painting. Black lines are used in the first step and another colour is introduced in the second and subsequent stages to illustrate what has gone before. I have used two colours so that you can follow the progression easily. When copying the steps, it is better for you to use a fairly soft HB, or B pencil. Do not press too heavily until you have finished the composition, as any unwanted lines can be erased.

When you are happy with the result, you can shade in the tonal values using various pencils to create depth. Start with a 2H or HB and move up to a 9B for the really dark areas. Then, having established the areas of light and dark, if you want to paint the flower, draw the image again and apply colour instead, following the same tonal values as the drawing.

However you choose to draw flowers, and whatever your style, if you follow my guidelines you will soon improve your drawing skills and become more confident. I hope some of your favourites are here as they are without a doubt some of mine, and putting them together in this next collection has been a pleasure, which I can now share with you all.

Happy Drawing!

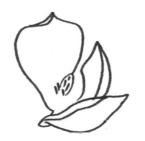

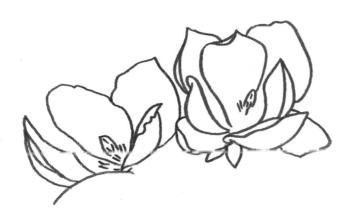

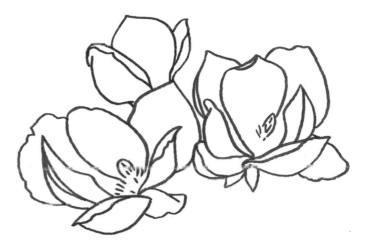

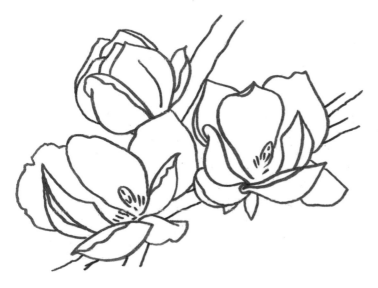

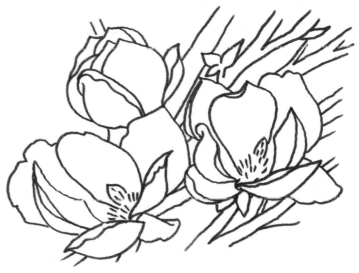

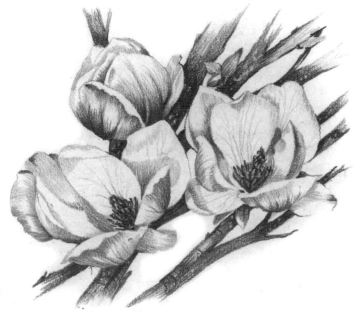

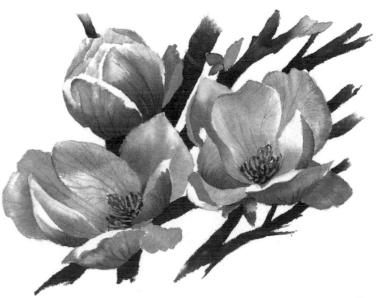

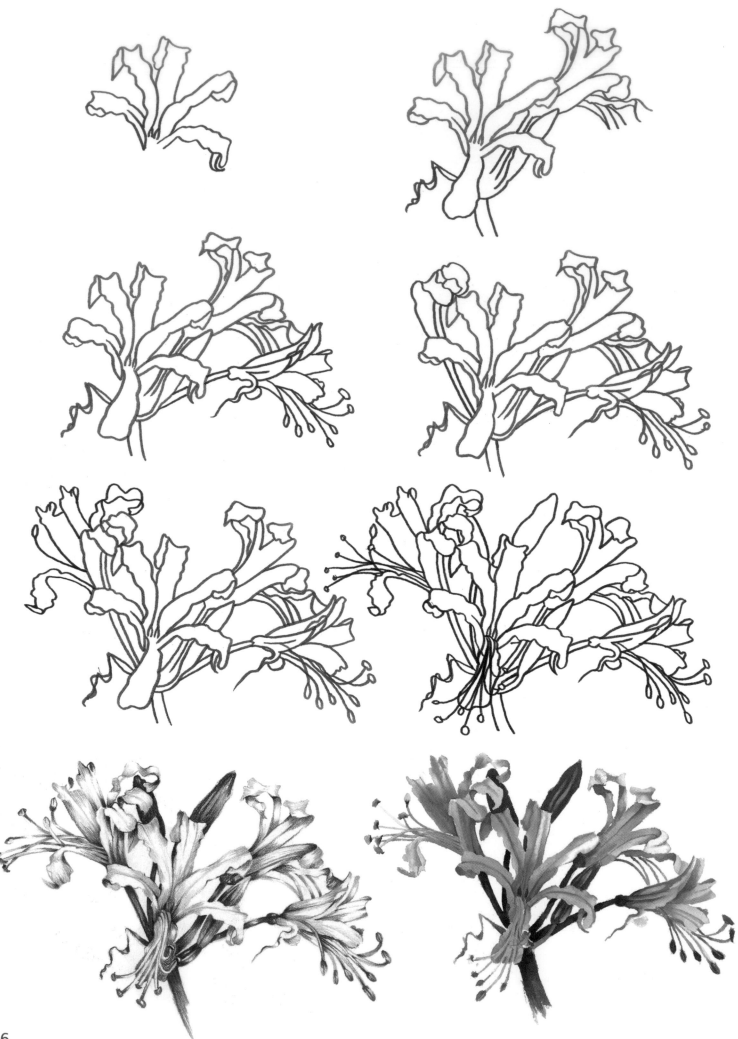

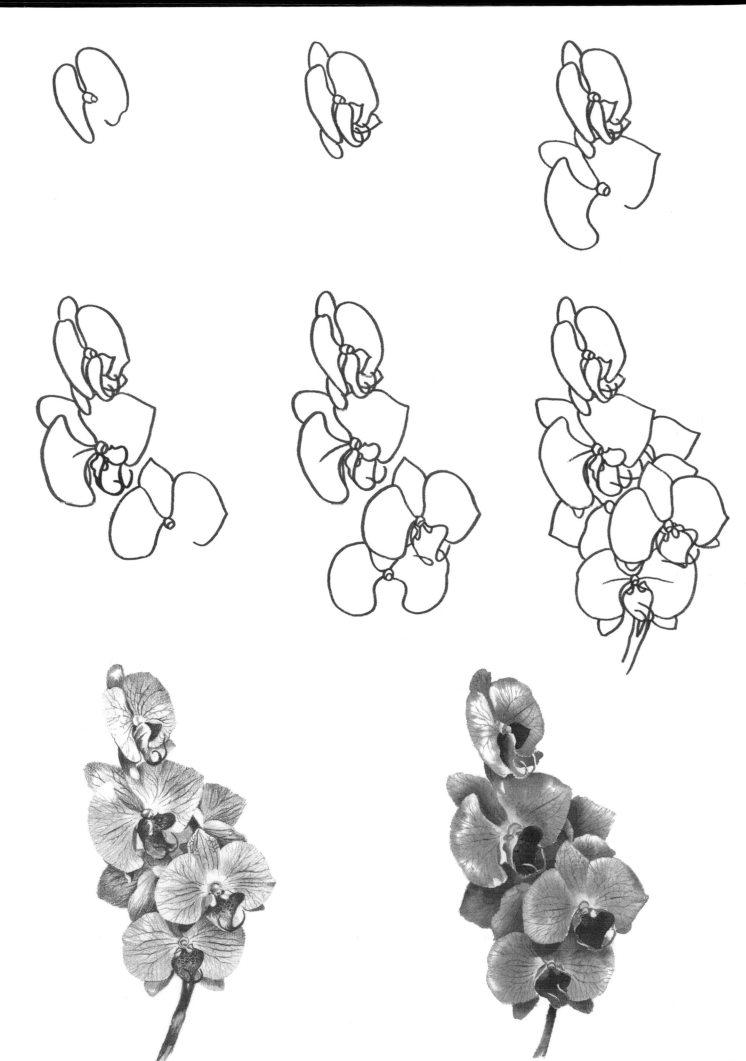

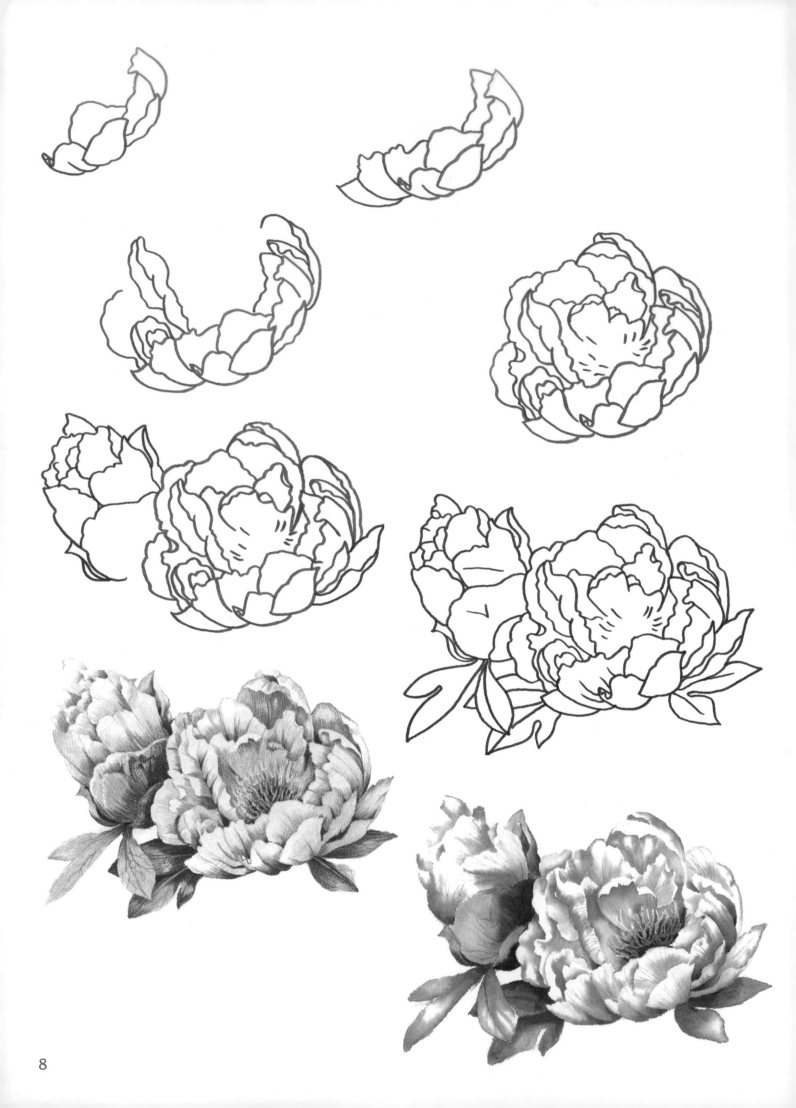

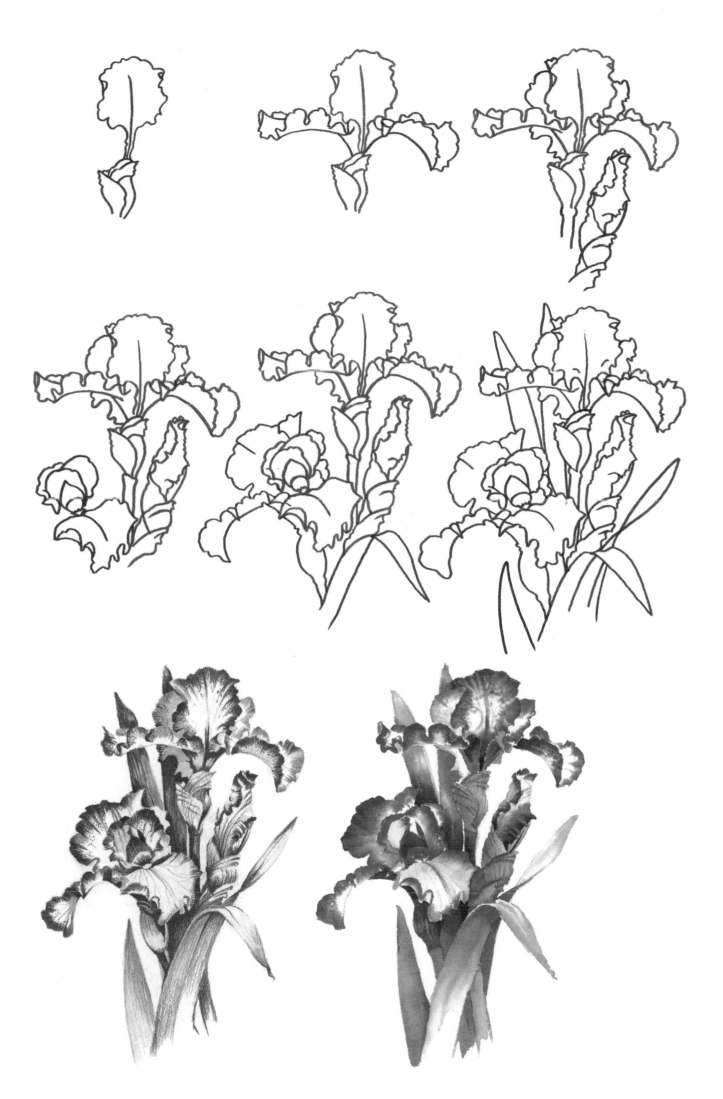

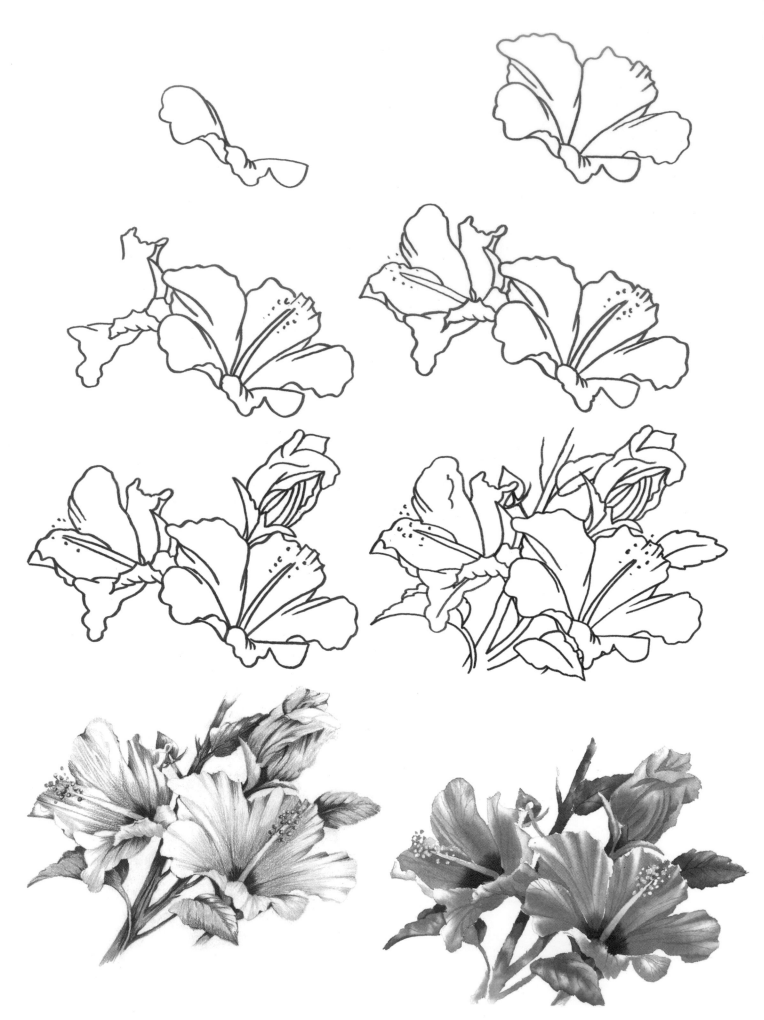

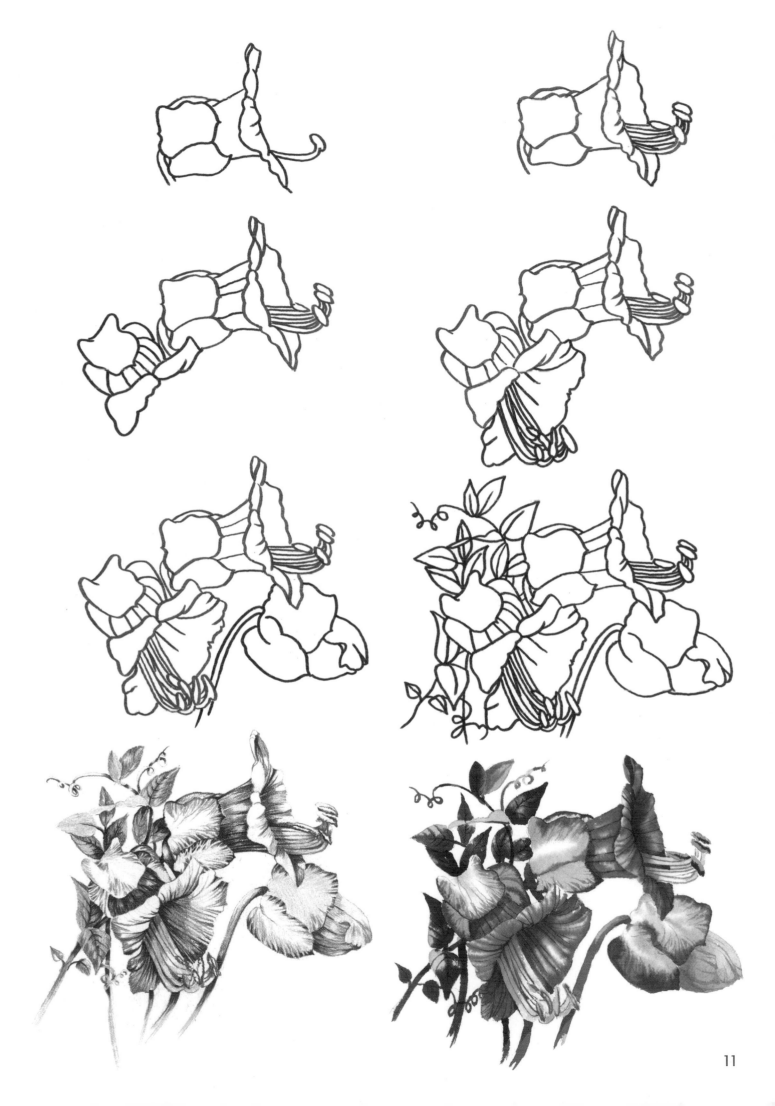

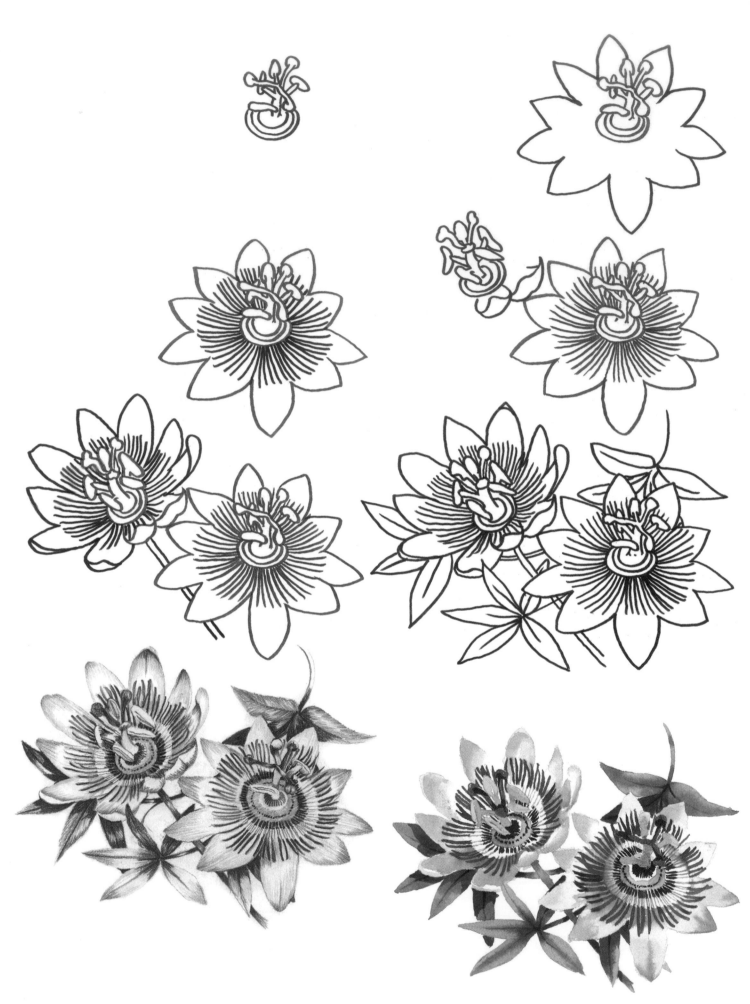

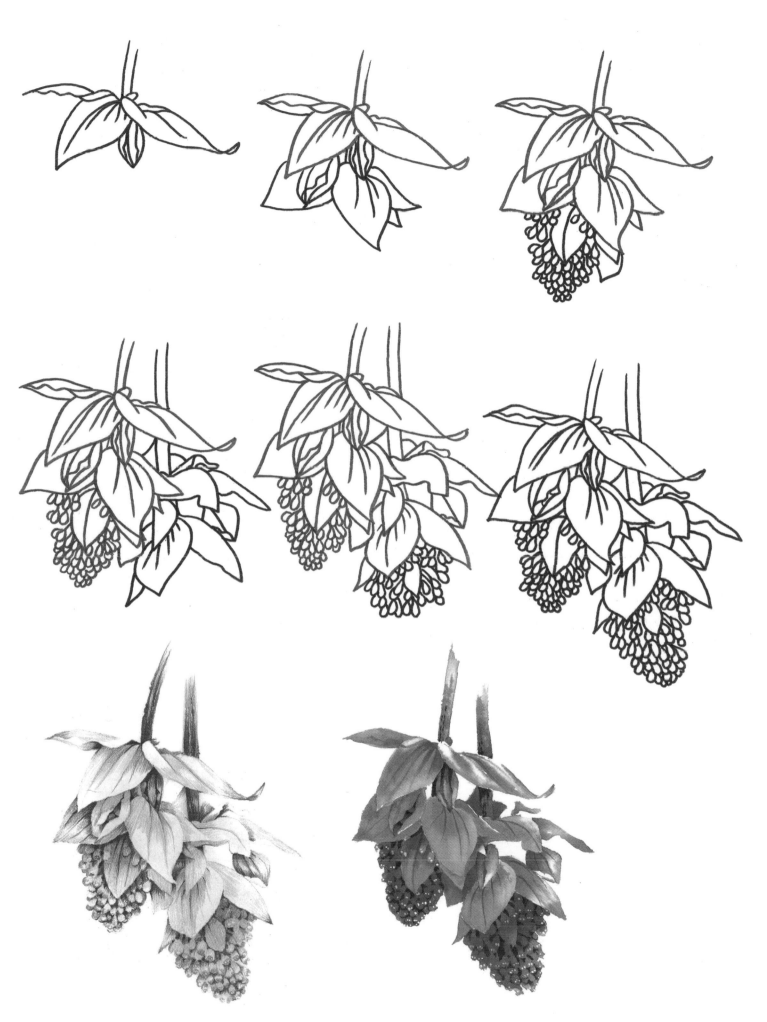

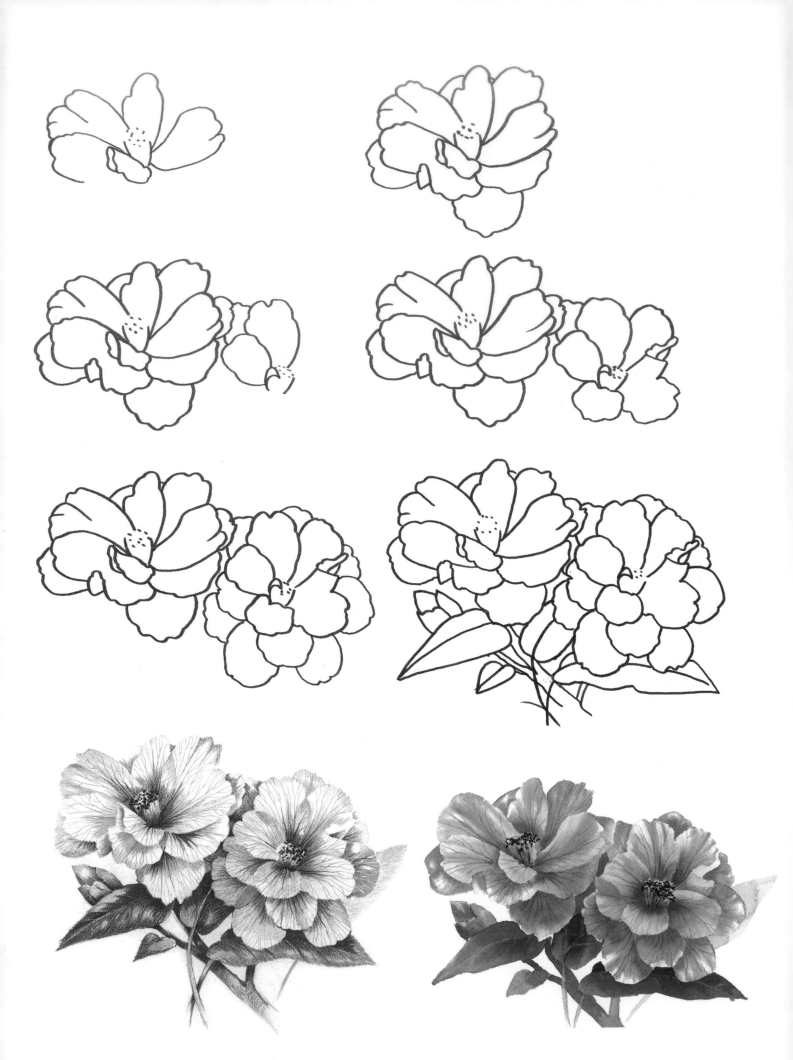

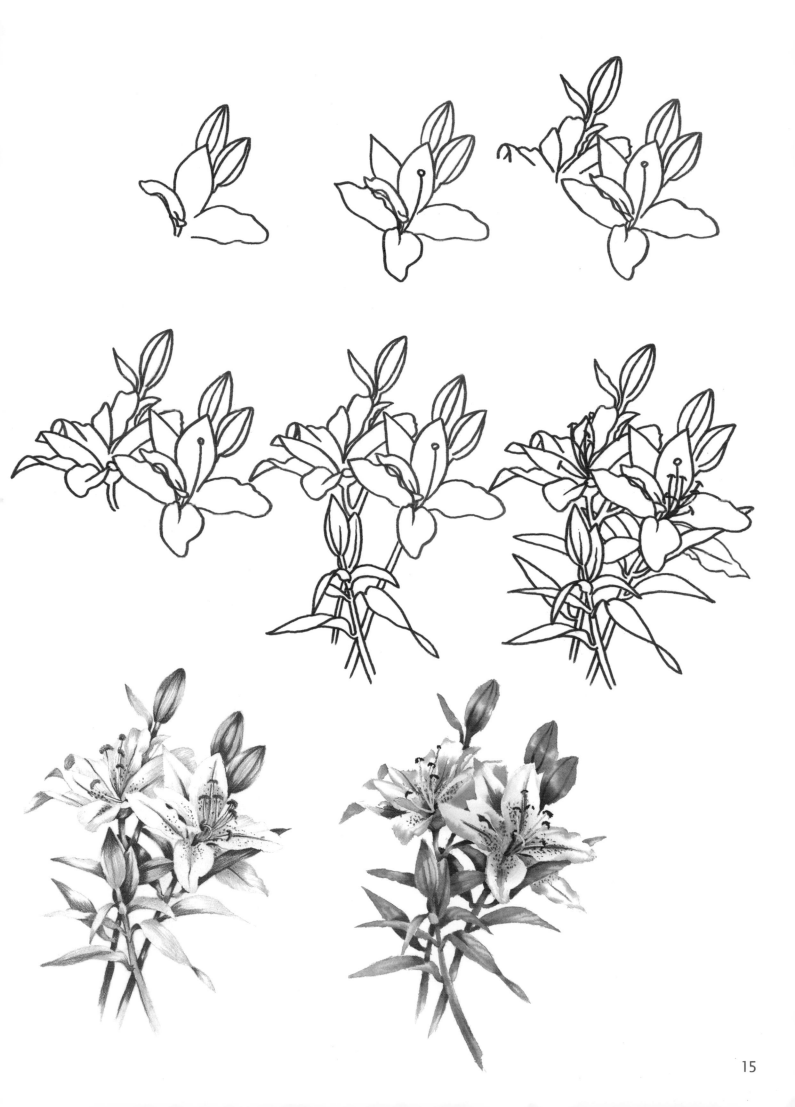

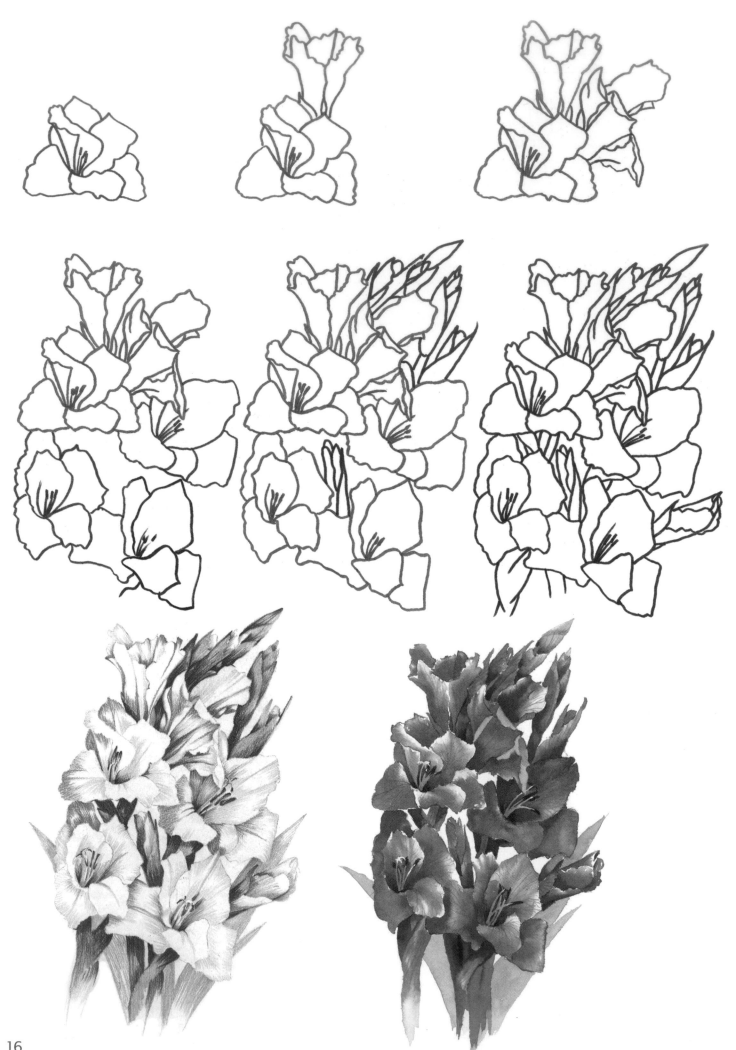

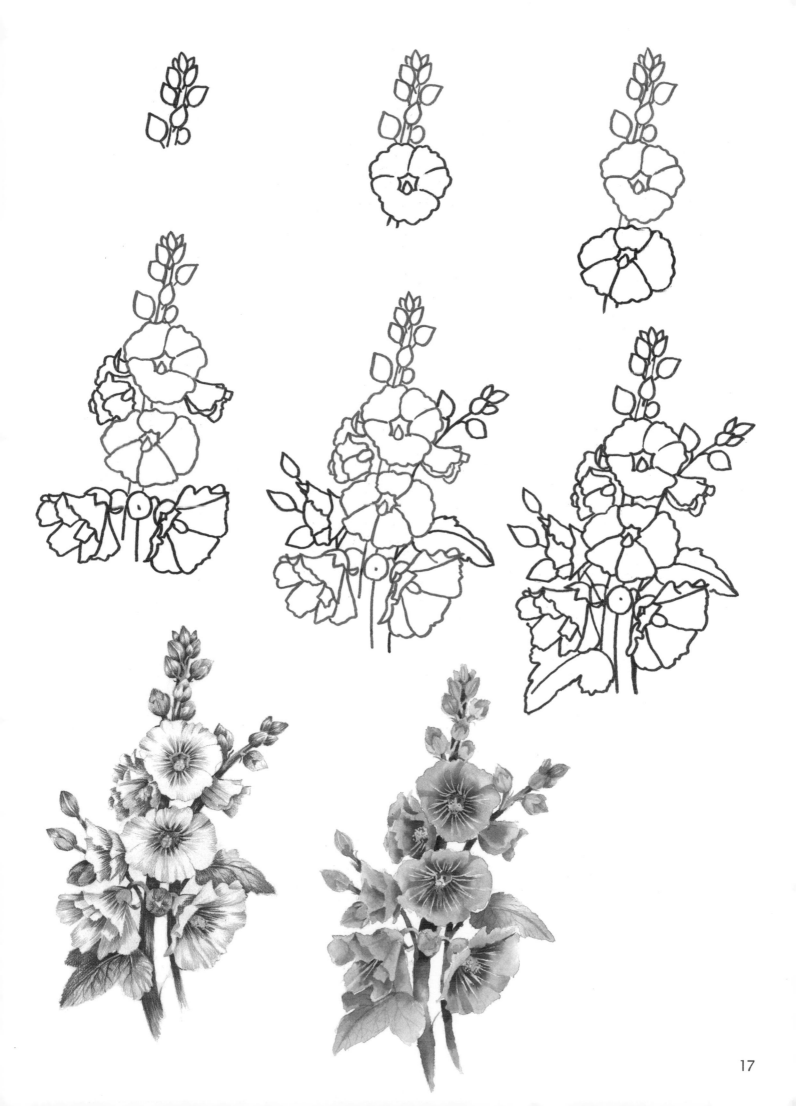

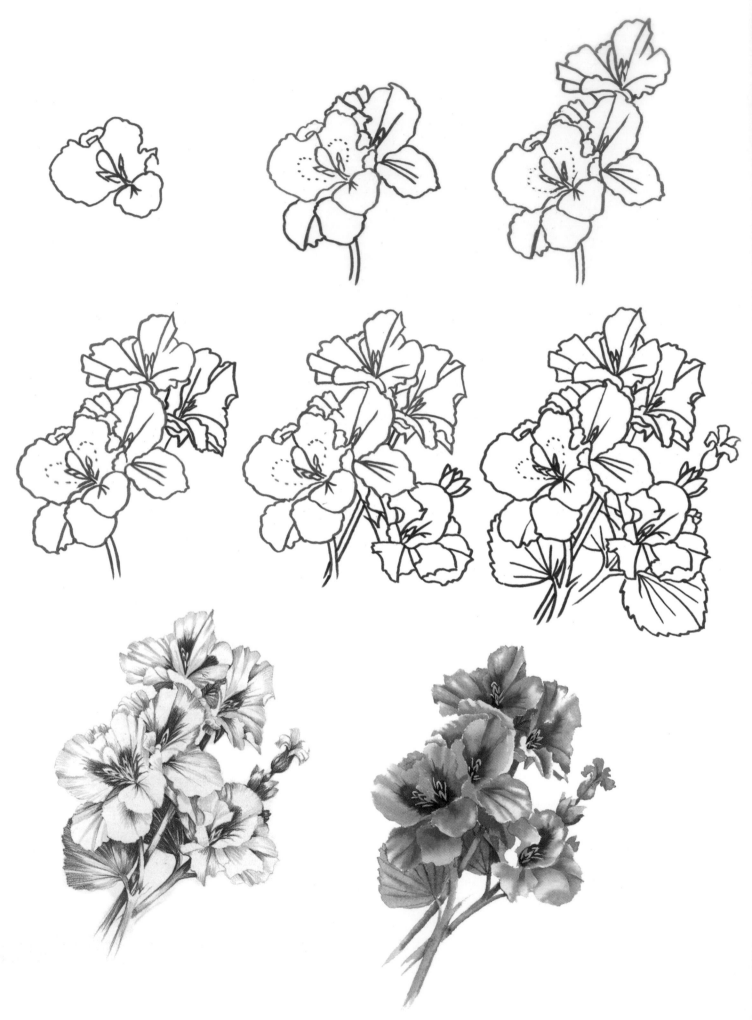

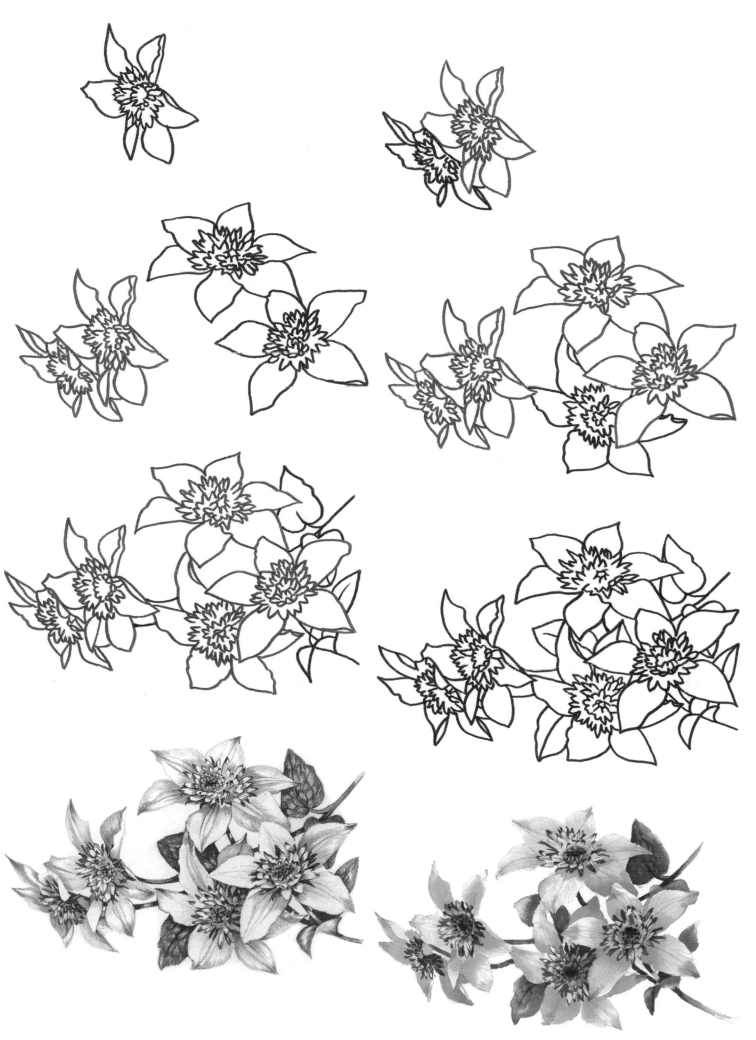

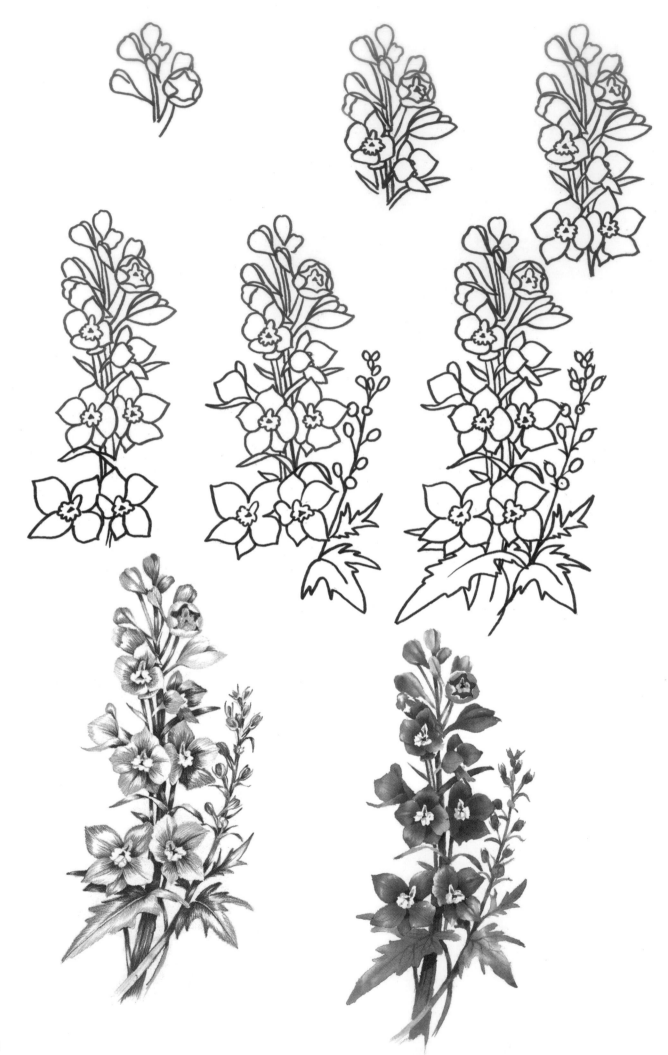

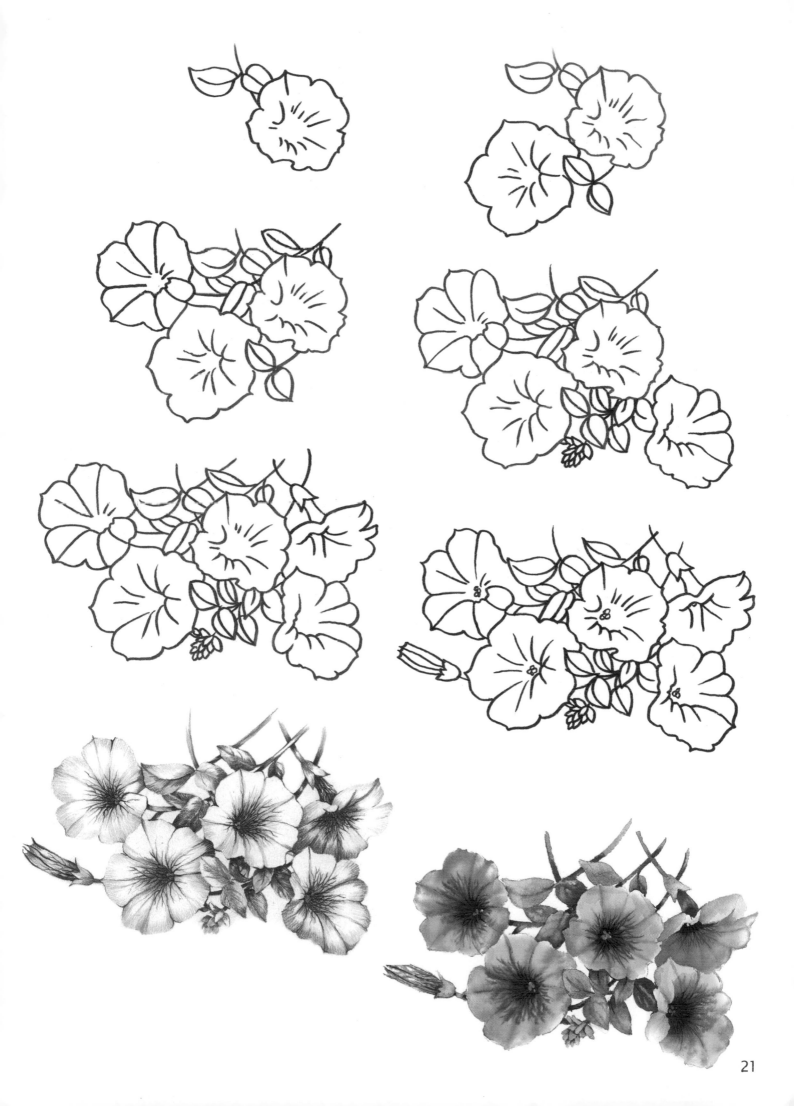

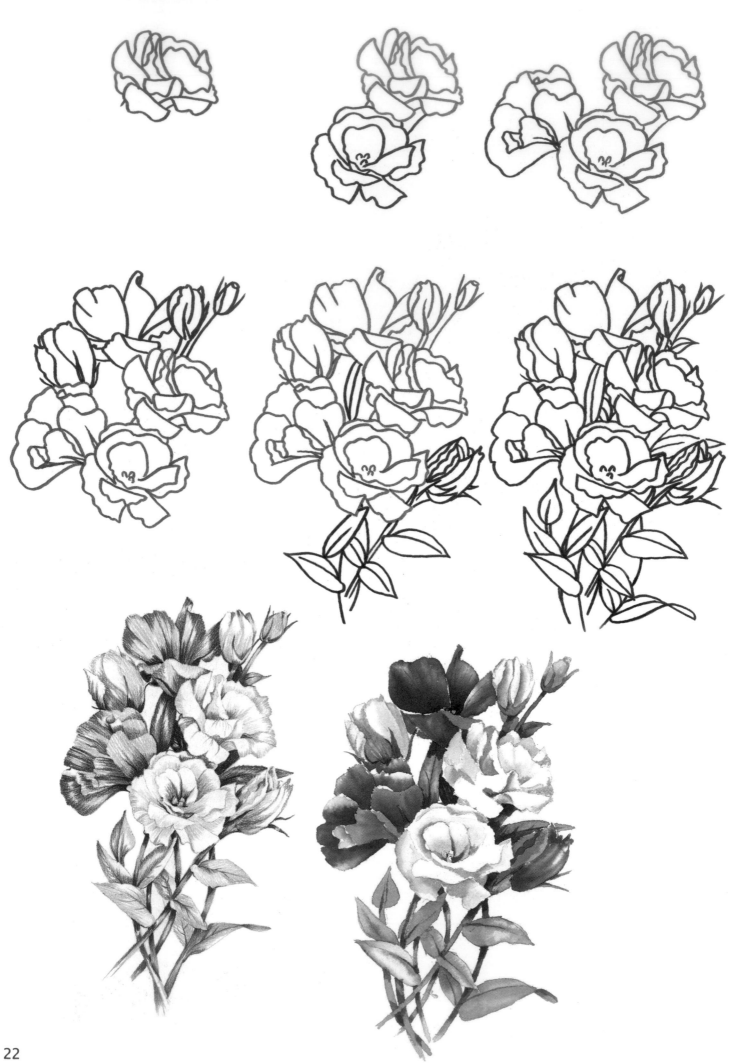

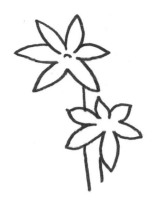

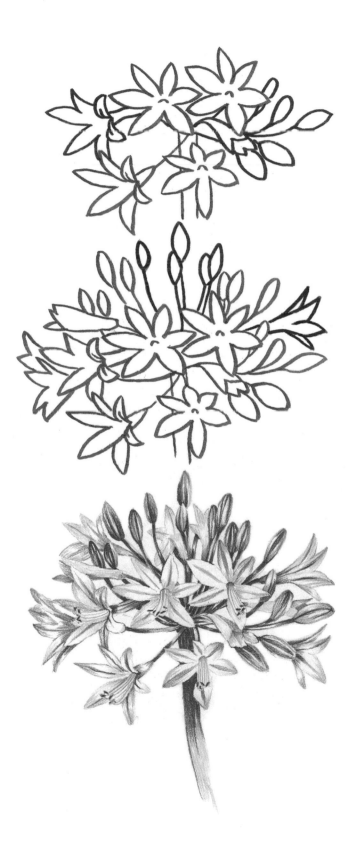

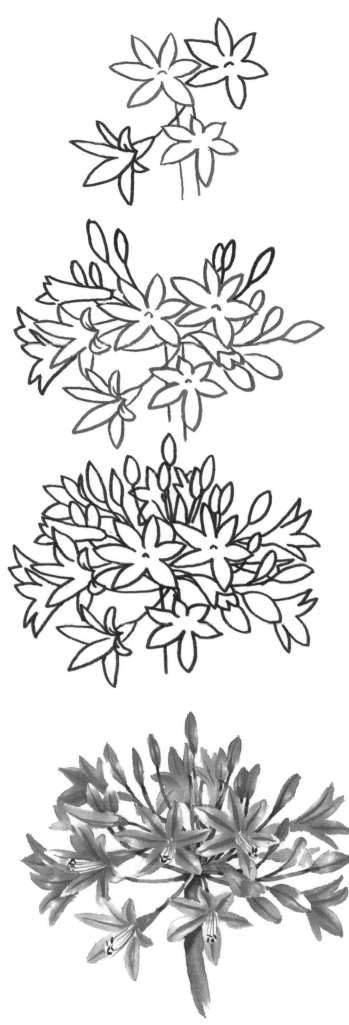

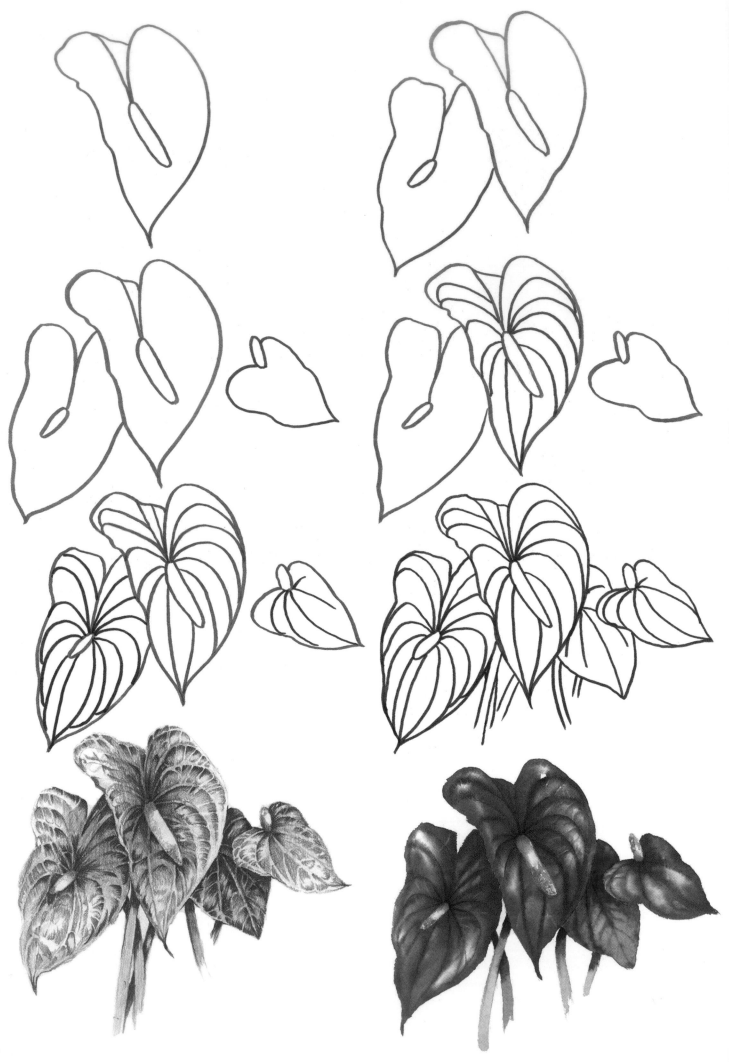

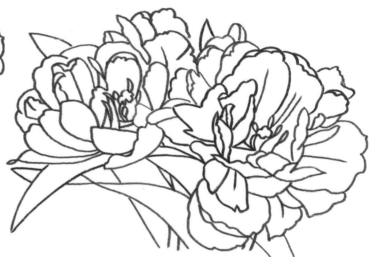

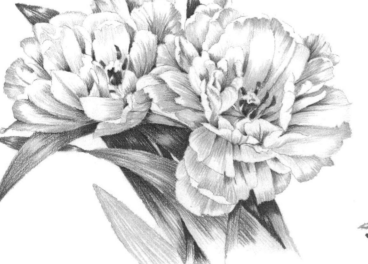

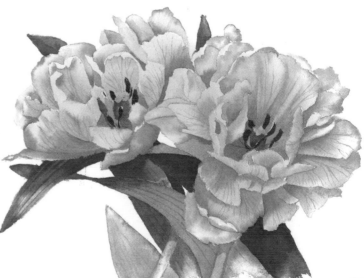

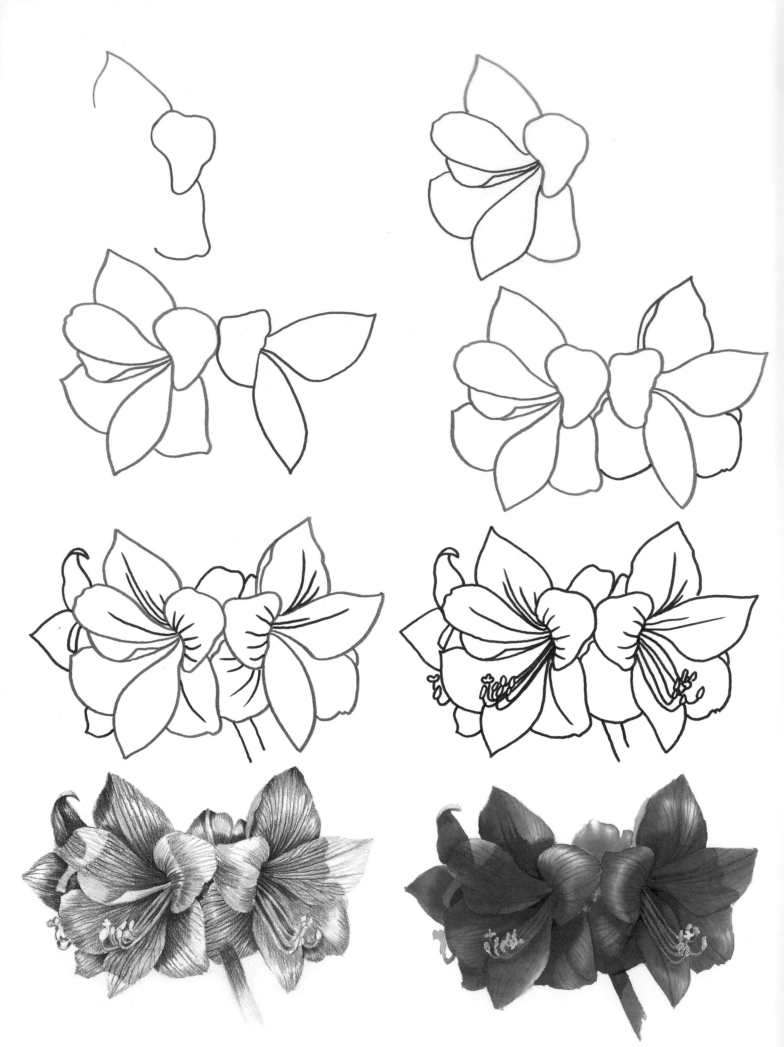

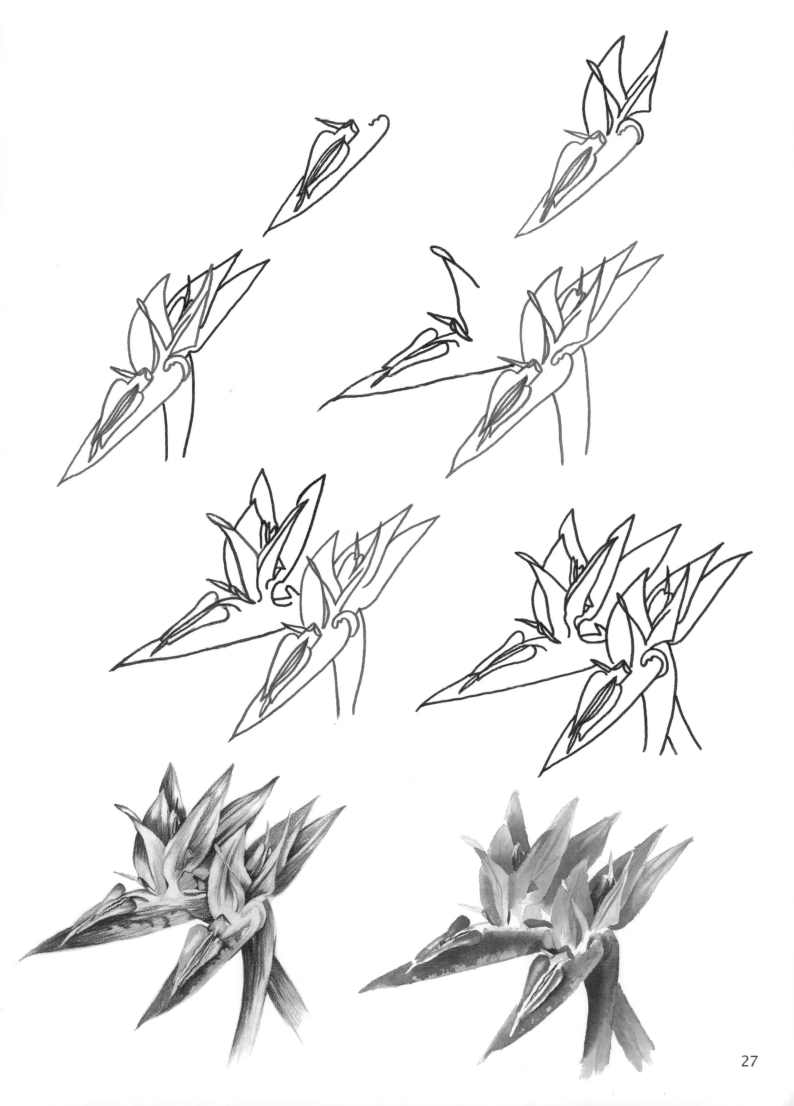

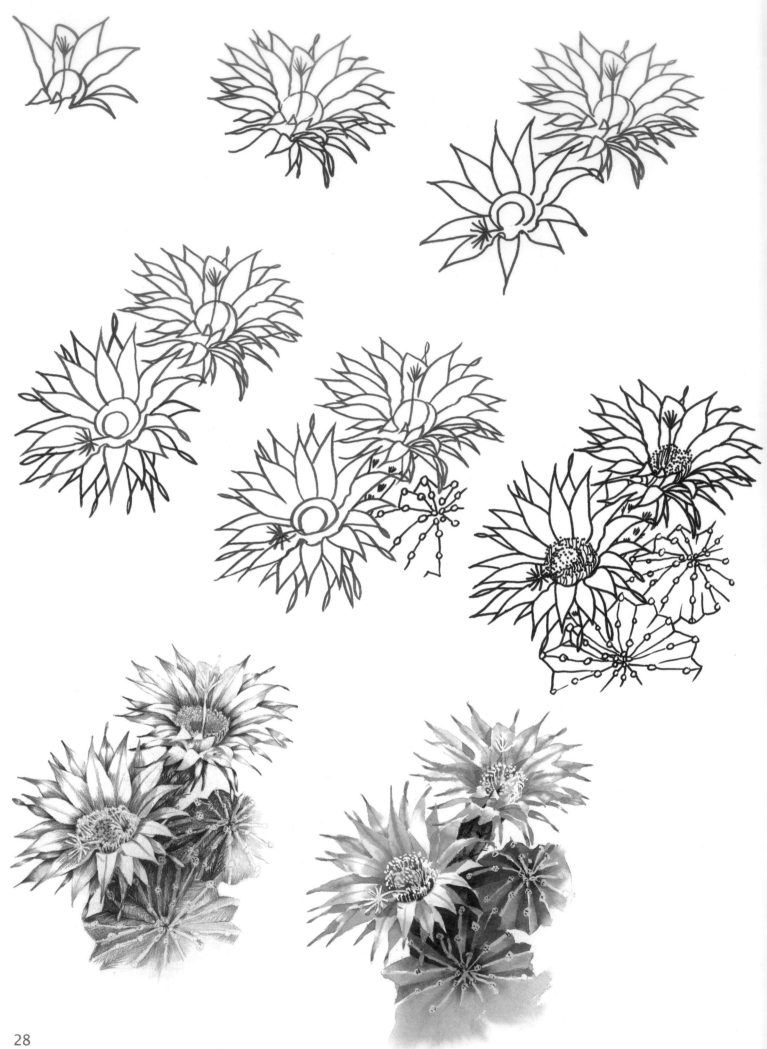

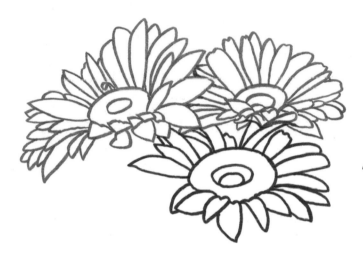

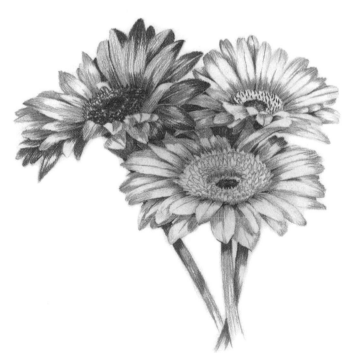

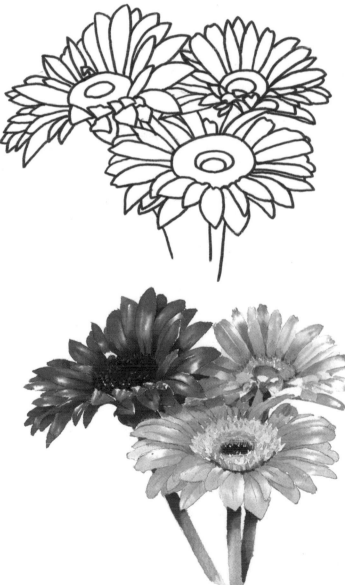

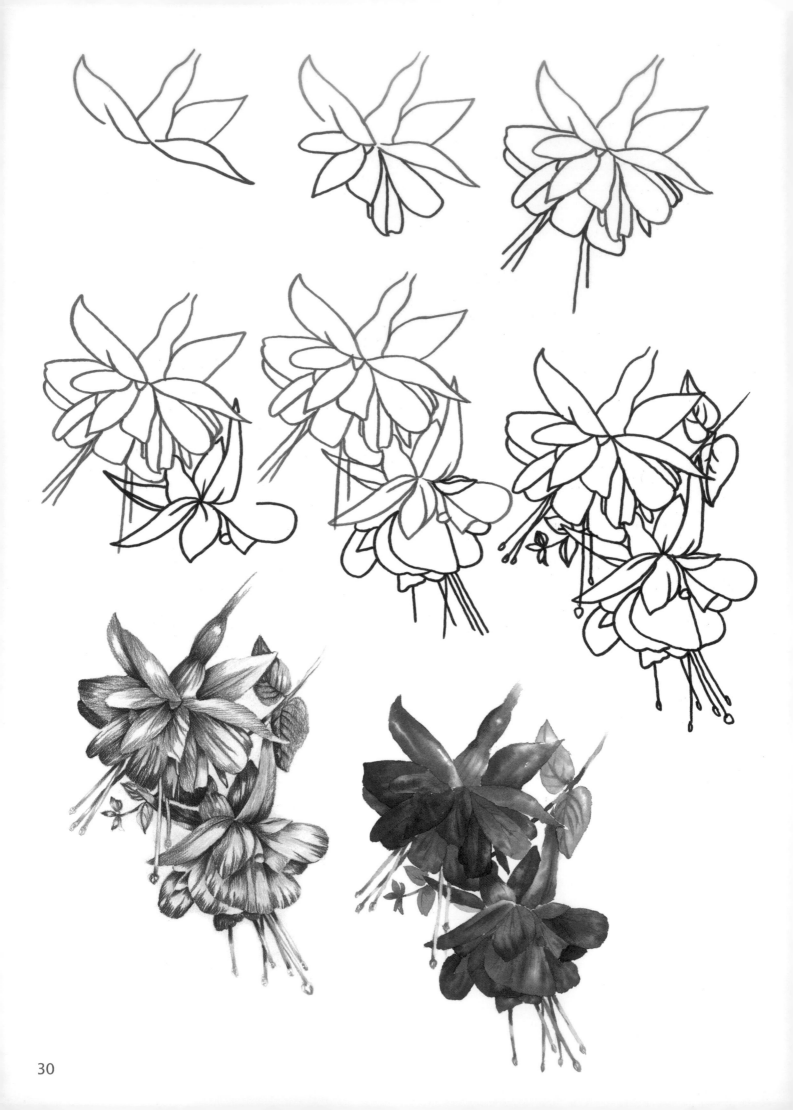

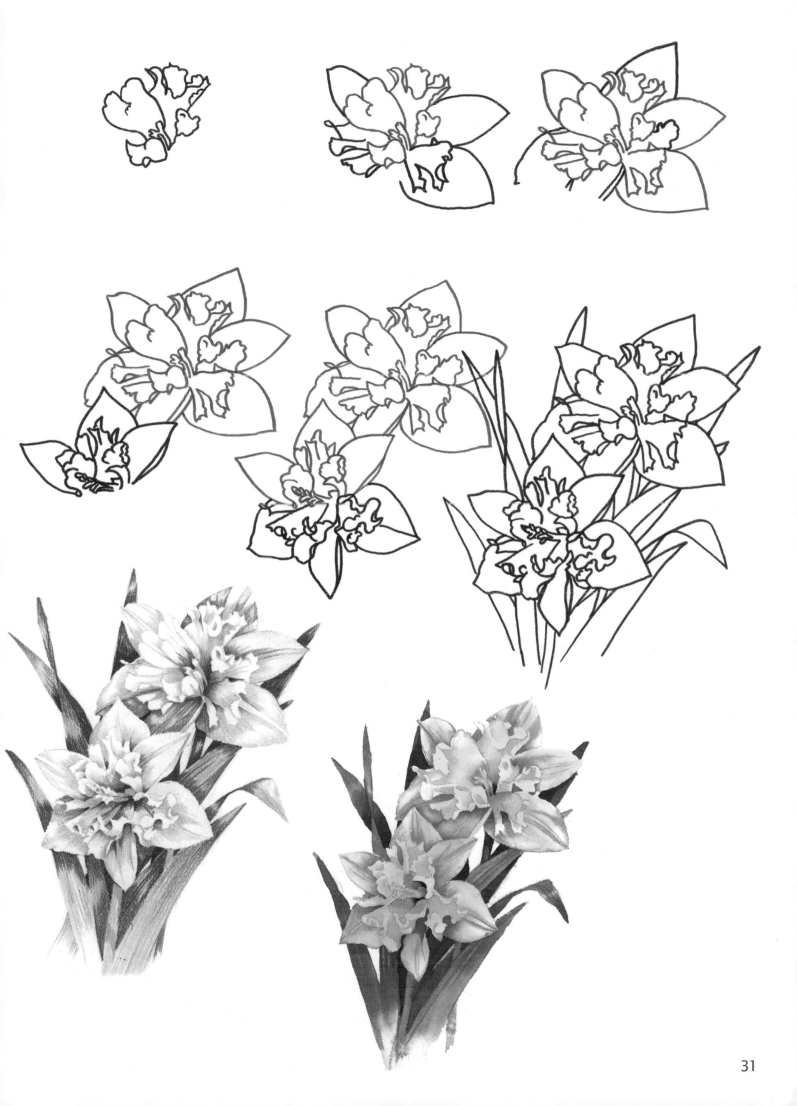

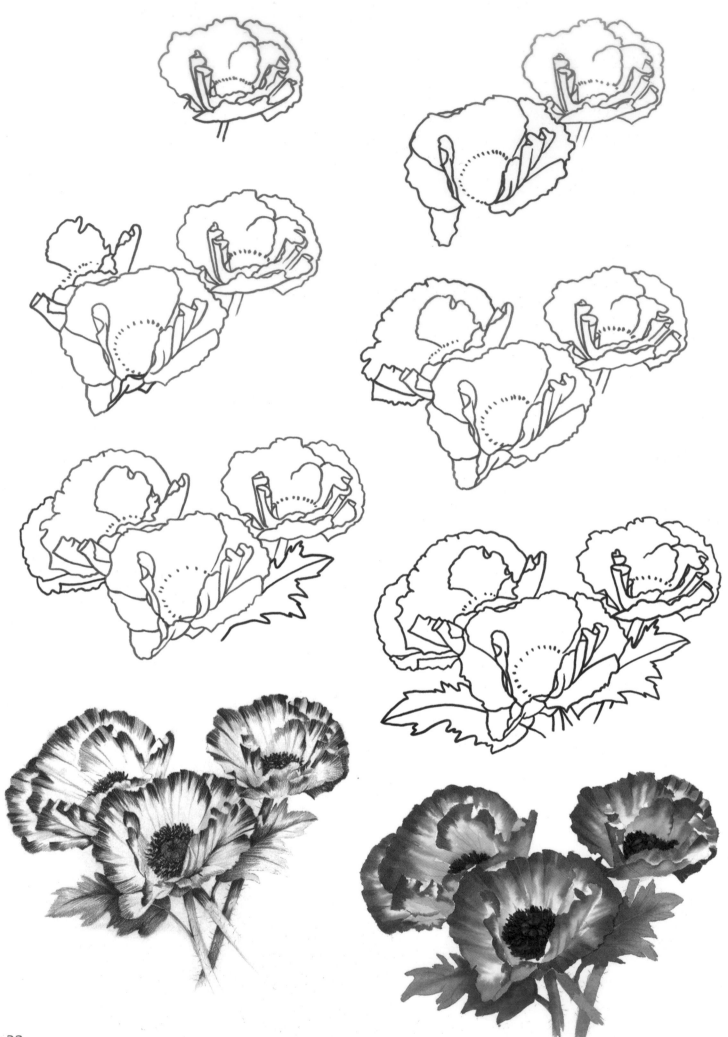